The Nude

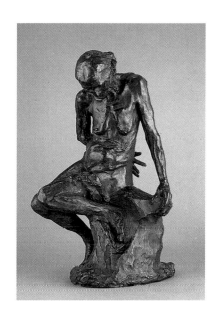

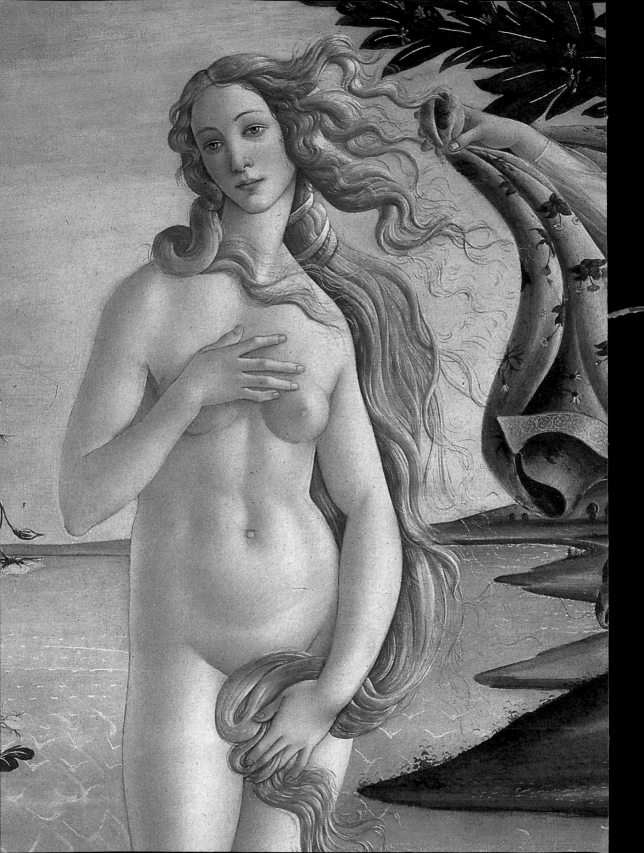

THEMES IN ART

The Nude

MONICA BOHM-DUCHEN

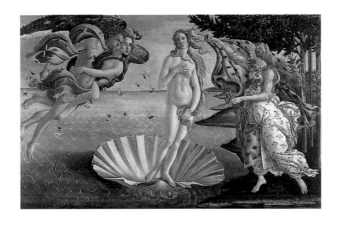

SCALA BOOKS

First published 1992

by Scala Publications Limited
3 Greek Street
London W1V 6NX

in association with

Réunion des Musées Nationaux
49 Rue Etienne Marcel
Paris 75039

Distributed in the USA and Canada by
Rizzoli International Publications, Inc
300 Park Avenue South
New York
NY 10010

ISBN 1 85759 004 X

Designed by Roger Davies
Edited by Paul Holberton
Produced by Scala Publications Ltd
Filmset by August Filmsetting, St Helens, England
Printed and bound in Italy by Graphicom, Vicenza

Photo credits: Artothek 17; Bridgeman
5, 7, 15, 25, 34, 37, 42; © RMN 9, 16,
19, 20, 21, 22, 23, 24, 27, 28, 29, 30,
31, 32; Scala (Italy) 5, 11; Pratt
Contemporary Art 43; Gwen Hardie
40; Sylvia Sleigh 41

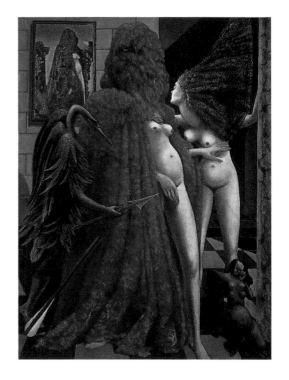

FRONTISPIECE **1** **Auguste Rodin**
She who was once the helmetmaker's beautiful wife,
1888
Paris, Musée Rodin

TITLE PAGE Detail and whole of **10**, Sandro
Botticelli, *The birth of Venus*

THIS PAGE Detail and whole of **37**, Max Ernst,
The robing of the bride

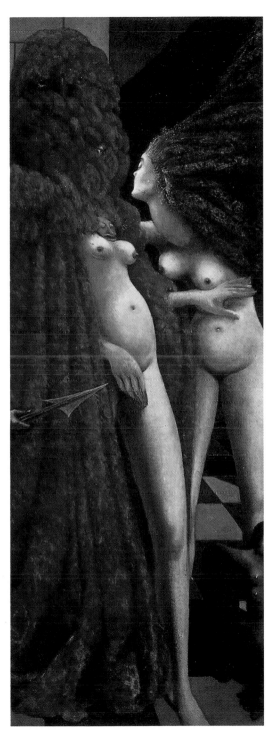

Contents

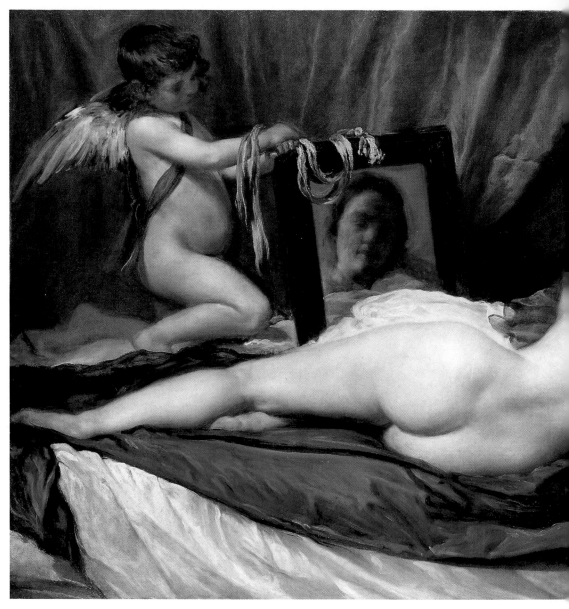

2 Diego Velázquez
The toilet of Venus ("the Rokeby Venus"), *c*1650
Oil on canvas, 122.5 × 177 cm
London, National Gallery

As with Goya's *Naked Maja*, this represents the artist's only major treatment of the female nude.
It was painted as a matching companion-piece to a sixteenth-century Venetian nude (now lost) in
the mould of Titian's *Venus of Urbino* (15): Velázquez's nude was seen from the back in deliberate
contrast to the Venetian nude seen from the front.

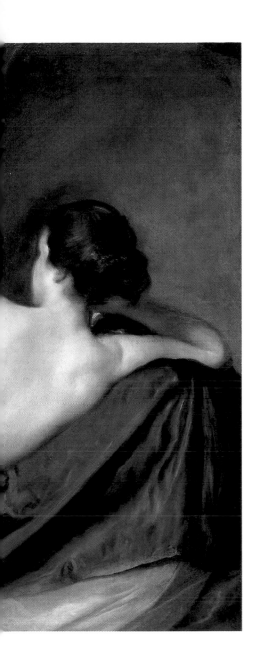

Introduction

As a central and crucial feature of our lives, sexuality is clearly a legitimate concern for serious art. Certainly, few subjects in Western art have proved as fundamental and compelling as the naked human body. At best, the nude can be a means of exploring the complex and often problematic relationship between the sexes in a way that is both thought-provoking and enriching.

If this book seems to place a great deal of emphasis on depictions of the female nude, that is because the female nude has indeed been the primary focus of artistic interest. Given the fact that most artists have been men, this is hardly surprising. Yet an important paradox exists in that, on the one hand, women in Western society have tended to be valued primarily for their physical attributes, while, on the other, men have often credited women with a "natural" modesty that has made it necessary to shield them from images of an explicitly sexual nature. When, in other words, male artists paint or sculpt a female nude, they tend to address themselves implicitly to other men. Nothing could illustrate this more clearly than an anecdote relating to Velázquez's Rokeby *Venus* (**2**). When, in the nineteenth century, the painting was hung in Rokeby Hall in Yorkshire, it was placed high above the chimney-piece, in order, we are told, that "the ladies may avert their downcast eyes without difficulty, and connoisseurs steal a glance without drawing the said posterior into the company."

For all her undoubted allure, the Rokeby *Venus*, like so many other painted Venuses, is primarily a naked female body displayed for the delectation of the male spectator. Cupid—that favourite device whereby adult male fantasies are mediated by the naked body of a male child—holds the mirror, the

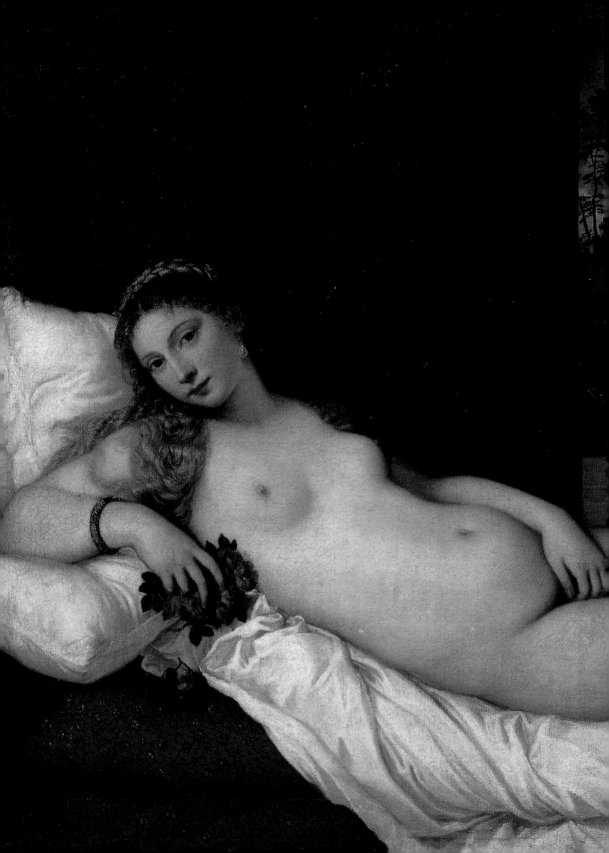

Detail of 15, Titian, _Reclining nude_ ("the _Venus of Urbino_")

This painting, the most famous example of a whole genre of such works produced in Venice in the sixteenth century, relies for its erotic impact on a formula that has since become a commonplace of Western culture: the seductive female body laid out for the (apparently private) delectation of the male spectator.

traditional emblem of vanity, thereby giving the viewer the flattering illusion of being privy to the woman's narcissism, although not condoning it. That a suffragette saw fit to attack the painting physically reveals how unacceptable this reduction of woman to passive recipient of the male gaze had become.

Like the anecdote just quoted, much writing on the nude in art describes images of the naked body in uncritical and sexually suggestive terms reminiscent of those often applied to the unclothed body in real life. Even more common is the tendency to aestheticize—and thereby anaesthetize—the subject by discussing it primarily in terms of form and color, an attitude encouraged by the rarefied, hushed, and almost sacrosanct atmosphere of the typical public art gallery. Today, neither attitude seems adequate. To look at the nude purely as a work of art tends to underestimate the significance of what is represented, and how; while to appraise it simply as a fine specimen of human flesh overlooks the fact that it embodies pervasive and potentially restrictive cultural stereotypes.

If the analysis that follows reflects unfavorably upon many of the artists, it is not because these artists have been out and out scoundrels intent upon the ruthless exploitation of women, but because, for all their technical mastery and formal inventiveness, artists rarely manage to transcend the sexual mores and preconceptions of their day. A more critical appraisal of the depiction of the nude in Western art can therefore reveal—to men and women alike—a great deal about the power relations existing in society.

Classical and Judaeo-Christian nudity

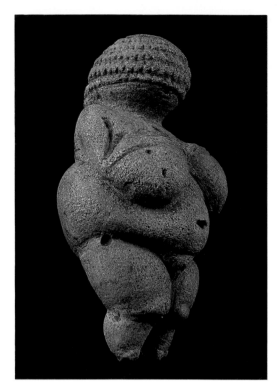

Among the very earliest extant images of the naked human body are a number of female fetish figures dating from the remote Stone Age (**3**). Unconcerned with anatomical accuracy but charged with a raw primeval energy, they speak eloquently of a culture in which the notion of a powerful earth-mother, fertility-goddess figure was dominant. A study of these sculptures reveals how deeply root-ed in human culture is the need to affirm woman's affinity with the forces of nature. Though these figurines are sometimes called "Venuses", they show rather how remote the Venus of classical statuary would become from the female deity's original sources of power.

It is the image of the classical nude, both male and female (**4**, **5**), that has exercised the longest-lasting control over the artistic imagination of the West. Since the Renais-sance, the classical nude has come to express a sense of bodily perfectability, of mathematical proportion imposing order on the vagaries of nature, a clean-cut nobility far removed from the reality of a living body, which excretes, gets diseased, grows old, and is usually imper-fectly formed in the first place. (The banishing of any sign of body hair is clearly a symptom of this.) Add to this the celebration of phys-ical beauty as the visible sign and literal embodiment of a life-affirming (albeit pagan) divinity, and we have a partial explanation of its enduring power. Paradoxically, an almost entirely physical concept of beauty was trans-formed into an almost abstract one— apparently universal, timeless, and classless.

In classical art important differences

3 Anonymous sculptor
"The *Venus* of Willendorf", paleolithic era
Limestone, 11.5 cm high
Vienna, Naturhistorisches Museum

A far cry from the streamlined ideal embodied by the classical Venus, this tiny figure, only the best known of many similar cult objects, radiates an emphatic and earthy physicality. Her exaggerated, rounded corpulence speaks clearly of a culture which valued woman above all for her fertility.

between the treatment of the male and female nude are apparent. Perhaps because in a period of increasing interest in the naturalistic depiction of the human body male artists turned most readily to a body closest to their own, it was the naked male form that dominated Greek art prior to the fourth century B.C. When the naked female comes into her own thereafter, she tends (as a comparison between the *Apollo* Belvedere (**4**) and the Medici *Venus* (**5**) makes clear) to offer herself primarily as an object to be viewed, in marked contrast to the more varied and predominantly active poses in which the male is depicted. Moreover, although it is commonly assumed that the apparent pride in nakedness so characteristic of classical art must have existed in everyday life, there is plenty of evidence to suggest that this was far from the case. In contrast to the men who stripped naked for exercise and were in any event scantily clad, women in ancient Greek society were kept carefully covered and as carefully segregated. And, as is rather better known, in educated society in classical Athens it was homosexual, rather than heterosexual love that was seen as the fullest and most noble of human relationships. So it could be argued that the ideal expressed in classical—and classicizing—art has served to deflect attention from real-life inequalities.

Convention has it that the advent of Christianity led to the complete, if temporary, suppression of nudity in Western art. However, examples of fertility figures survive in Early Christian churches; distinctly erotic carvings exist in Romanesque and Gothic churches, and in medieval *objets d'art*—jewelry, decorated furniture, manuscripts, and so on— adorned with risqué motifs. Moreover, it is a fact of cultural history that early representations of Christ were stylistically influenced by images of Apollo, albeit stripped of his original meanings. Yet by the fourth century A.D., a Christian poet could write (not perhaps without a hint of regret): "Hearts pledged to Christ are closed to Apollo;" and a Byzantine legend, in relating how a sculptor who gave Christ the body of Jupiter found his hands withered and useless, reminds us of the powerful Jewish fear of idolatry inherited by the Christian Church.

Shame and guilt about nakedness lie at the very heart of the Judaeo-Christian worldview. After all, the first indication of Man's fallen state, as related in the Book of Genesis, is that Adam and Eve recognized their nakedness and sought to cover it from view. The few New Testament subjects in which the naked body has a central and logical place, notably the Expulsion from Eden, the Flagellation of Christ and his Crucifixion and Entombment, and the devotional subjects of the Man of Sorrows and the Vesperbild or *Pietà* (Christ's body held by his mother) (**6**), are all embodiments of extreme pathos. The body is no longer the expression of divine beauty as in classical art, but a mere repository, cumbersome and temporary, for the soul—hence, presumably, the lack of interest in its naturalistic representaton. Such depictions suggest that only perhaps through the suffering and death of the body can the soul be liberated.

Here again the female is differentiated from the male. In the eyes of the Bible (itself the product of a patriarchal worldview) and the early Fathers of the Church, it was Eve, formed out of Adam's rib, who, succumbing to the blandishments of the Serpent, was truly the sinner, and therefore she and her female descendants must be forever subject to the authority of the male. Sexual attraction became irrevocably associated with danger and death: as St. Paul put it with admirable brevity, "To be carnally minded is death." The virulence of Early Christian attacks on women

4 Anonymous sculptor
The *Apollo* Belvedere, Roman copy of a Greek original
Marble, 223.5 cm high
Rome, Vatican Museums

Excavated in 1479, this statue fired the imaginations of countless artists. (Two hundred years ago, it was one of the most famous works of art in the world. Winckelmann, high priest of eighteenth-century Neoclassicism, described it thus: "It is the highest ideal of art among all the works of antiquity. Enter, O reader, with your spirit into this kingdom of beauty incarnate, and there seek to create for yourself the images of divine nature."

5 Anonymous sculptor
The Medici *Venus*, Roman copy of a Greek original
Marble, 153 cm high
Florence, Uffizi

Benjamin West eloquently revealed the reasons for this statue's almost sacred status. "Were the young artist . . . to propose to himself a subject in which he would represent the excellences of women . . . would he not bestow on the figure a general, smooth, and round fullness of form, to indicate the softness of character, bend the head gently forward, in the common attitude of modesty; and awaken our ideas of the slow and graceful movements peculiar to the sex, by limbs free from that masculine and sinewy expression which is the consequence of active exercise?"

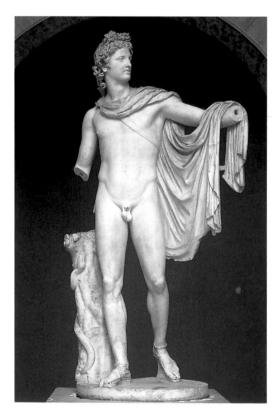

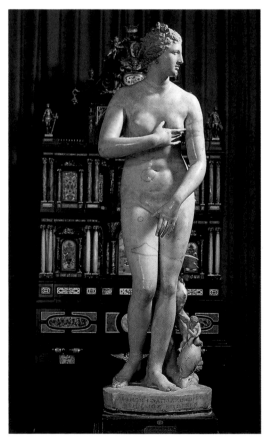

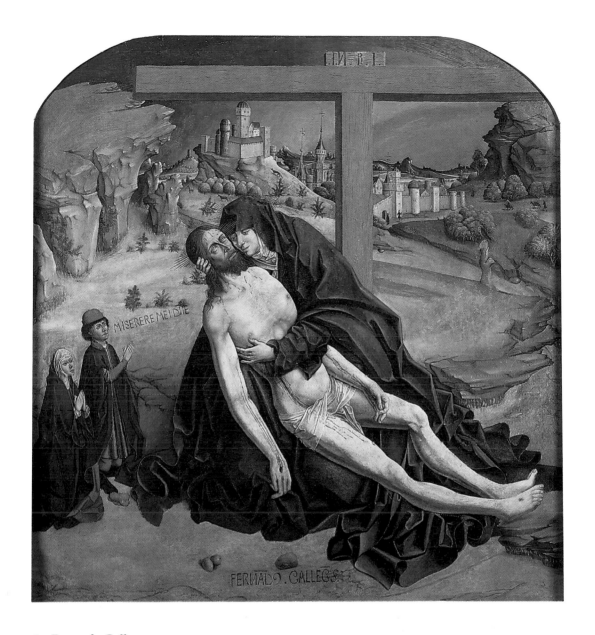

6 Fernando Gallego
Pietà, with two donors, late 15th century, Oil on panel 118 × 102 cm
Madrid, Prado
The "Pietà" (Italian for "pity") appears first in Byzantine art of the twelfth century. Early
Renaissance art, as in this example, followed the medieval precedent of portraying the body of
Christ lying across the knees of the seated Virgin. Gallego has clearly been influenced by the
meticulous realism of fifteenth-century Netherlandish painting, but endows the scene with a
peculiarly Spanish emotional intensity.

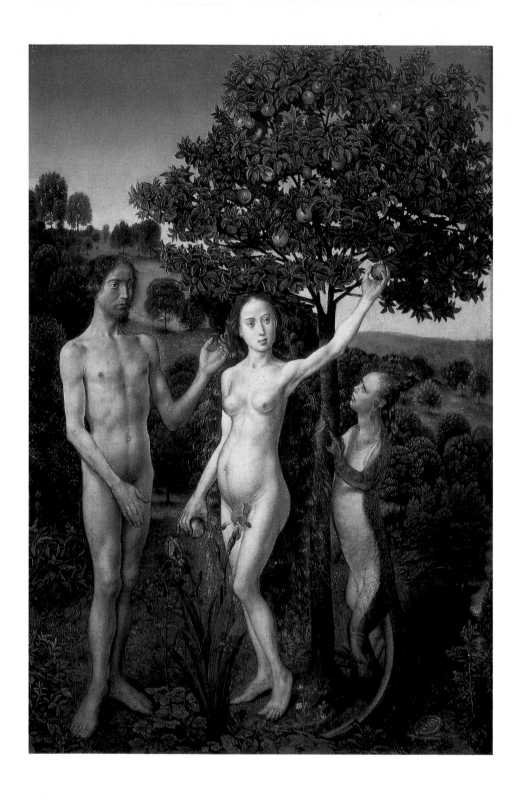

7 Hugo van der Goes
Adam and Eve, c1470
Oil on panel, 34 × 23 cm
Vienna, Kunsthistorisches Museum

Significantly, neither has yet eaten of the apple, but Adam has already placed a hand over his genitals, while a conveniently placed iris performs the same function for Eve. In contrast to the stiffly angular Adam, however, and her curious proportions notwithstanding, Eve is portrayed as sinuously provocative, a deliberate analogy being drawn between the apples she holds and her small, rounded breasts. Even the serpent is endowed with distinctly feminine features.

is astonishing. St. John Crystostom, for example, declared: "The whole of her bodily beauty is nothing less than phlegm, blood, bile, rheum, & the fluid of digested food ... When you see a rag with any of these things on it, such as phlegm and spittle, you cannot endure looking at it ... Are you then in a flutter of excitement about the storehouses of these things?" Though neither is represented completely naked, it is worth noting that two of the main female protagonists in the story of the life of Jesus, his mother Mary and Mary Magdalene, are women with singular destinies. Mary, herself born "immaculate" (of a virgin), gives birth to Jesus untainted by human sexual intercourse; Mary Magdalene, the repentant whore, on one level clearly represents female sexuality made safe. Here the madonna/whore dichotomy so pervasive in Western culture finds its earliest and original expression.

When Eve emerges in the art of the Renaissance (**7**), it is not surprising that she is rendered with considerably more ambivalence than Adam. As the first transgressor, burdened with the guilt of her disobedience, and the first temptress as well, she is frequently depicted as both sinful and alluring, a creature to be condemned, pitied, and sexually desired simultaneously. Significantly, images of Eve were more common in northern Europe than in Italy, where the classical heritage still lingered.

Visual emphasis on the suffering, mutilated bodies of Christ and his saints came relatively late in the development of Christianity. When it did, it is striking how often the male bodies are shown as passively enduring, even on occasion enjoying their martyrdom, which they undergo naked, albeit with their genitals modestly covered by a loin cloth. The third-century Roman martyr St. Sebastian was a favorite subject (**8**). Patron saint of both

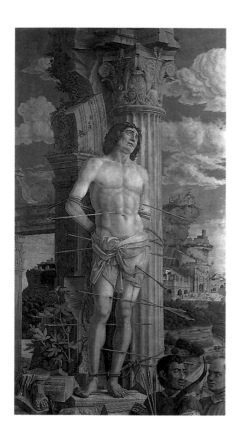

archers and plague victims, he was tortured with arrows, although he actually met his death by being bludgeoned and thrown into the main sewer of Rome. Medieval art tends to show the whole cycle of his sufferings; Renaissance art, on the other hand, concentrates on the archery episode, which gave artists, newly concerned with naturalism and anatomical accuracy, ample opportunity to show the near-naked male body in action. Antonio and Piero Pollaiuolo's *Martyrdom of St. Sebastian* (**9**) is a case in point. However, in contrast to the virile and muscular archers, the body of the saint remains an object of eroticized pathos.

8 Andrea Mantegna
St. Sebastian, c1459
Canvas, 275 × 142 cm
Paris, Louvre
Although the classical ruins are clearly meant to be read as a symbolic reference to the fall of Rome and the triumph of Christianity, Mantegna is just as clearly fascinated by the athletic male nude of classical art. St. Sebastian's virility, however, is subverted by the greenish pallor of his flesh and his passive, even pleasurable submission to his fate.

9 Antonio and Piero Pollaiuolo
The martyrdom of St. Sebastian, c1475
Tempera on panel, 291.5 × 202.6 cm
London, National Gallery
One of the most striking aspects of this monumental altarpiece is the dramatic contrast between the active, straining bodies of the archers, whose poses almost schematically echo each other, and the passive, eroticized figure of the saint. Tradition has it that the Sebastian was a portrait, representing one Gino di Ludovico Capponi.

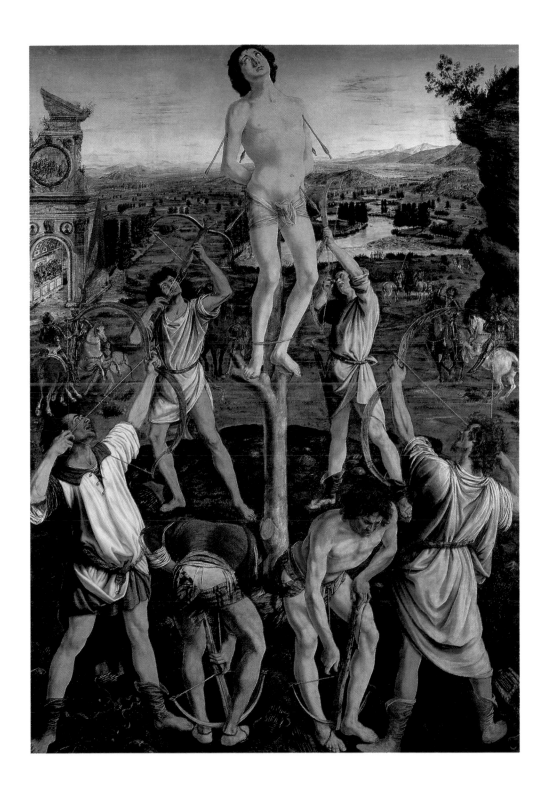

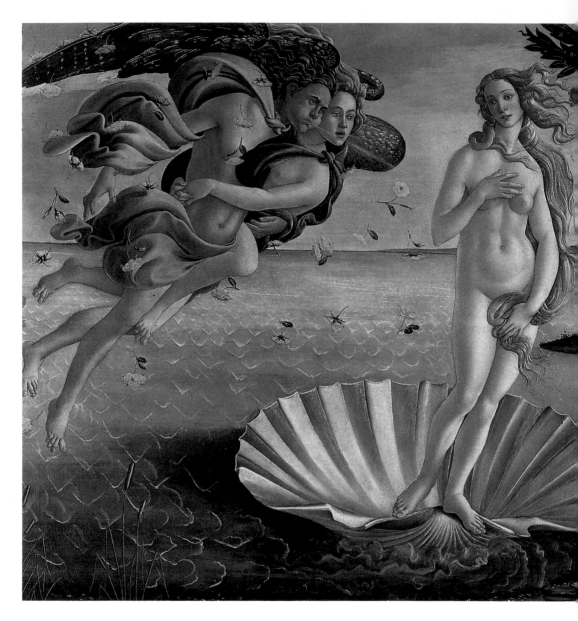

10 Sandro Botticelli
The birth of Venus, c1480
Canvas, 175 × 278 cm
Florence, Uffizi

According to classical mythology, Venus was born from the foam produced by the genitals of the castrated Uranus when they were cast upon the waters. She rose out of the sea near the island of Cyprus, and was wafted to shore by the Zephyrs (west winds) where she was greeted by the Seasons (here represented by the single figure of Spring).

The Nude in Renaissance and Baroque art

One of the first major paintings to resurrect the naked Venus, and thereby testify to the resurgence of interest in classical themes and values that was so central a feature of the Italian Renaissance, was Botticelli's *Birth of Venus* of about 1480 (**10**). The goddess's pose is derived directly from that of the antique Medici *Venus*, as is the almost sculptural treatment of her body. Her improbably sinuous locks act both as extra protection and as an invitation to the curious (as artfully placed drapery was to do in countless later images of the female nude). The overall rhythms of her body, however, are distinctly unclassical and her expression is far more wistful and self-conscious than that of an antique Venus. Indeed, it has often been noted that her features are disconcertingly similar to those favored by Botticelli for his Madonnas. A strongly Christian sense of beauty as the fragile container for a pure and humble soul coexists here with a deeply sensuous appreciation of the female form, making for a curious combination of sensuality and innocence—an important part, presumably, of the painting's perennial appeal.

Just as Venus was resurrected, albeit in a form modified by the Christian conscience, so, too, Apollo emerged from centuries of disapproval into the light of fifteenth-century Europe. In contrast to Venus, who was soon to become a synonym for feminine desirability, the forms he took were various, the most famous of them probably being Michelangelo's *David* (**11**). Conceived as a Florentine tribute to Republican Rome, this statue is a typical

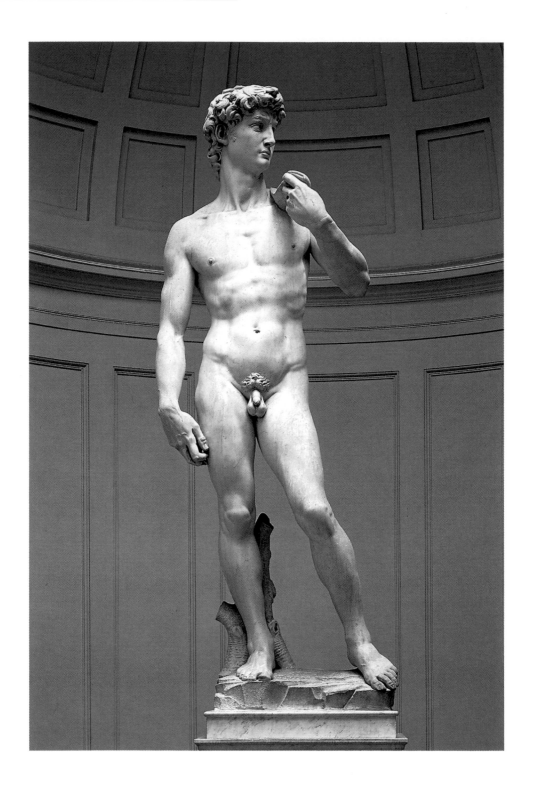

example of the use of classical nudity to embody abstract virtues. However, it can also be seen, at least in retrospect, as a reflection of the sculptor's homosexuality. (More blatant is the languorous homo-eroticism of a work like the *Dying slave* of *c*1513, in the Louvre.) Even in its own day the *David*'s nudity was controversial. When placed in Florence's Piazza della Signoria in 1504, the statue was stoned during the night, probably out of a sense of moral outrage on the part of decent citizens, and was soon made respectable by the now familiar addition of a fig leaf.

In marked and poignant contrast to Michelangelo's *David*, though of exactly the same date, stands Dürer's *Naked self-portrait* (**12**). Purportedly drawn for the artist's doctor as an aid to diagnosis, this is a remarkably honest image that has few counterparts prior to the twentieth century. Instead of a confident, glamorized nudity bordering on arrogance, we have here a man stripped naked in all his imperfect particularity, whose tensed and knotted body confirms and reinforces the self-searching intensity of his expression. In spite of the fact that Michelangelo's sculpture is as much a public statement as Dürer's drawing is a private one, the two works provide a telling example of the contrast between Italian and Northern Renaissance attitudes to the

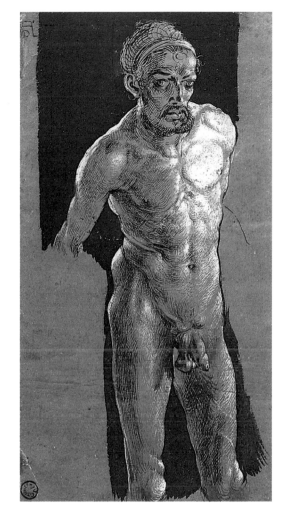

11 Michelangelo Buonarroti
David, 1501–4,
Marble, 410 cm high
Florence, Accademia

Directly inspired by the *Apollo* Belvedere (4), this monumental statue represents a Christian, homosexual artist's heroic defiance of Christian inhibitions about the body. It stands in marked contrast to the abiding image of the passive female, as typified by Giorgione's *Venus*, painted only a few years later.

12 Albrecht Dürer
Naked self-portrait, *c*1503
Pen and wash on paper, 29.1 × 15.3 cm
Weimar, Schlossmuseum

In contrast both to Michelangelo's *David* (11) and to some of his own attempts at heroic, classically inspired nudes, Dürer produced at least two naked self-portraits. (In the other, now lost, he went so far as to cast himself in the role of Christ.) Almost painfully honest in its self-scrutiny, this intimate image has few counterparts until the twentieth century.

body: the former idealizing and defiantly affirmative, the latter ambivalent and uncertain, still burdened by a sense of Christian guilt.

Another persistent feature of Renaissance art is the elongation of the female form, apparent in Botticelli's *Venus* and widely found in Northern European art of the period, for instance in Cranach's *Cupid complaining to Venus* (**13**). Although divergent from the dominant classical convention, these proportions, too, represent a kind of erotic ideal. Although a moralizing text accompanies the image to warn the viewer of the perils of love, the erotic intent of Cranach's painting is unmistakable. Venus, naked except for the necklace and extraordinary headdress which only accentuate her nudity, is an object of lascivious contemplation, made all the more titillating by her come-hither expression and the fact that her pose, as she grasps the tree laden with apples, at once recalls that of Eve in Northern images of the Fall.

By the 1530s, when the painting by Cranach was produced, Venus, and above all the reclining Venus, was well on the way to becoming a stereotype of Western art. The fact that there seem to be few classical precedents for the reclining female nude makes its appearance in the early sixteenth century even more revealing. Giorgione's beautiful *Venus* of about 1510 in the Gemäldegalerie, Dresden, is usually credited with being the first image of its kind. Indication that she is a classical goddess was originally provided by a Cupid who (later painted out) once accompanied her, complete with arrow suggestively poised. For all her undeniable allure, she paves the way for countless images of passive women laid out for the pleasure of the male spectator. Inevitably today these images seem to testify to men's unconscious need to dominate women sexually, under the guise of

13 Lucas Cranach the Elder
Cupid complaining to Venus, 1530s
Oil on canvas, 81.3 × 54.6 cm
London, National Gallery

This purports to illustrate a poem from the third century B.C. by Theocritus called "The Honeycomb Stealer". Part of the Latin text appears in the top righthand corner, with the added inscription: "So in like manner the brief and fleeting pleasure which we seek injures us with sad pain." Yet the headdress of this sexy Venus flatteringly recalls those of the fashionable ladies of the Wittenberg court, which commissioned the painting, while her links with the biblical Eve only increase her erotic appeal.

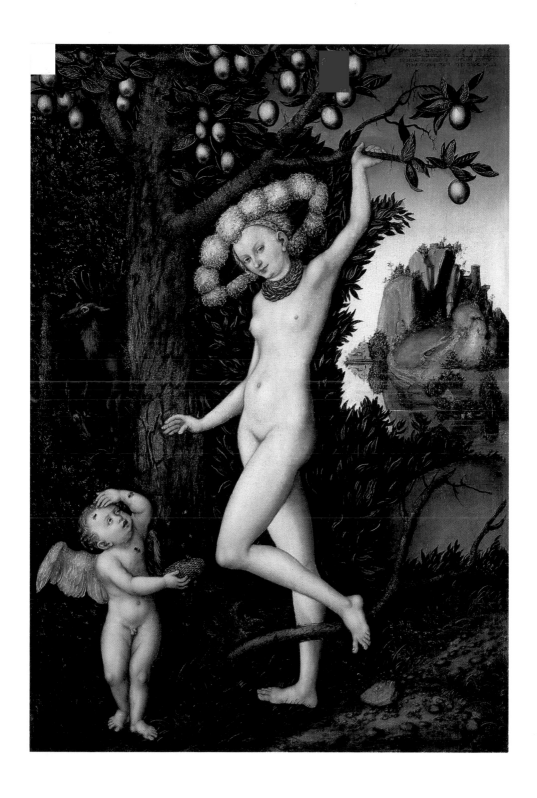

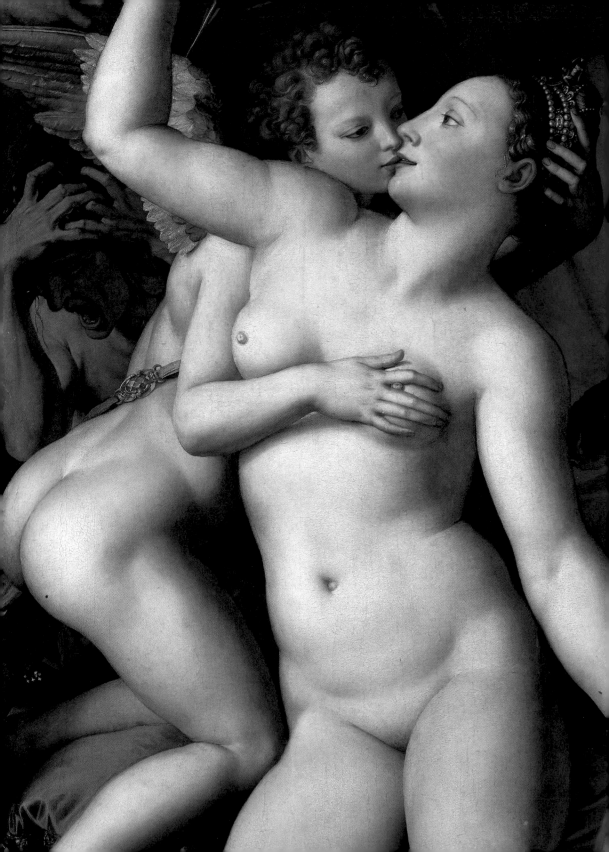

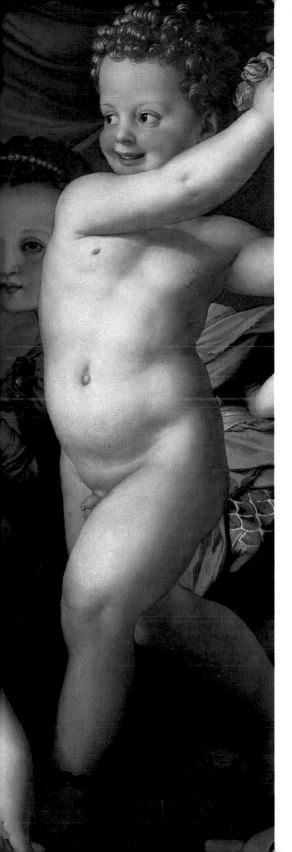

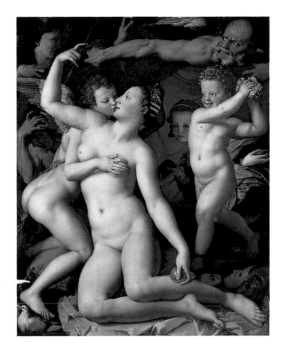

14 Agnolo Bronzino
An allegory of love and time, c1545–46
Oil on canvas, 146 × 116.2 cm
London, National Gallery

This complex, brilliant allegory, possibly
commissioned for the French king François I, is
a highly sophisticated pictorial statement of
Renaissance views about human sexuality.
Venus and Cupid, joined in an exquisite kiss,
are surrounded by figures who represent the
nature and consequences of the sexual act – its
joy and pleasure (flowers and a honeycomb –
compare 13), its transience and emptiness (the
masks, the woman top left who has only half a
head), its pain physical and mental (the man
who screams with the symptoms of syphilis,
the sting in the tail of the woman offering the
honeycomb).

Detail of 14

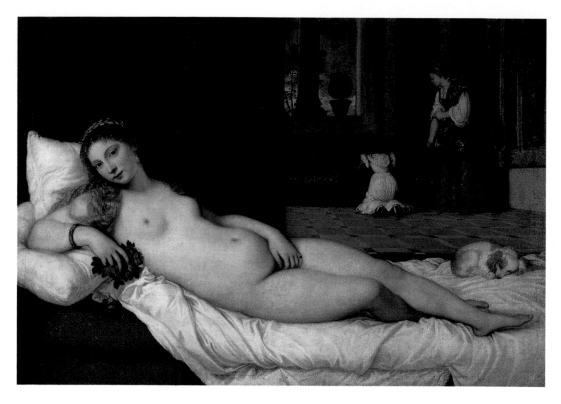

15 Titian
Reclining nude ("the *Venus* of Urbino"), 1536
Oil on canvas, 119 × 165 cm
Uffizi, Florence

Scholars in recent years have attempted to "rescue" Titian's reclining nude from the domain of pornography by reading it as an allegory or as a marriage picture designed to bring luck to the new couple. However, contemporary letters indicate clearly that it was enjoyed by its male owners as a lascivious and arousing image of female beauty. They looked at it perhaps less hypocritically than the spectators of Manet's *Olympia* (**29**), which was based on this work.

paying homage to their beauty.

Titian's so called *Venus of Urbino* (**15**) is a direct heir to Giorgione's painting. The latter had shown a completely naked woman reclining, eyes closed, in an idealized rural setting, so that her body too can be read as an apparently timeless landscape for the eye to roam over—an anodyne reworking of the ancient alliance of woman and nature. Titian, however, has transposed the figure to a contemporary interior, given piquancy to her nudity by the addition of jewelry, and provocatively opened her eyes. Many scholars have been reluctant to place this image on the level of a "pin-up", but that is undoubtedly what it is. The richly sensuous treatment of paint for which Venetian artists became renowned is ideally suited to the rendering of the seductive female nude. Indeed, it cannot be accidental that the two developments, of style and sub-

ject, went more or less hand in hand.

Venus and the other goddesses of classical mythology—as well as nymphs prey to the amorous exploits of Jupiter—were not the only suitable sources for erotic subject matter. Certain Old Testament subjects served a similar purpose. Favorite among these were the stories of David and Bathsheba, and of Susannah and the Elders, both of them notable for the passive role played by the woman and the opportunity for voyeurism afforded the (implicitly male) spectator. Tintoretto's treatment of the latter subject (16) is a case in point. Whether we wish to or not, we are compelled to identify with the old men who spy on the hapless Susannah. (The clothed attendants only accentuate the nudity of the protagonist.) By showing her staring back at the spectator, however, Tintoretto has transformed her from the victim of a dubious

16 Jacopo Tintoretto
Susannah and the Elders, **1550**
Oil on canvas, 167 × 238 cm
Paris, Louvre

An apocryphal Old Testament heroine, Susannah was a chaste wife, secretly desired by two community elders. Spying on her as she bathed, they threatened to accuse her of adultery unless she surrendered to their lust, which she refused to do. Tintoretto, like so many other artists, manages to transform her from a symbol of vindicated purity into a shameless hussy.

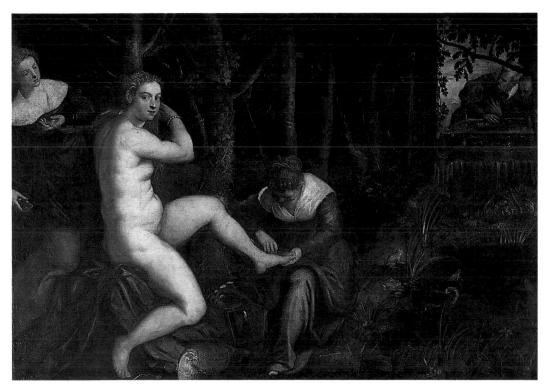

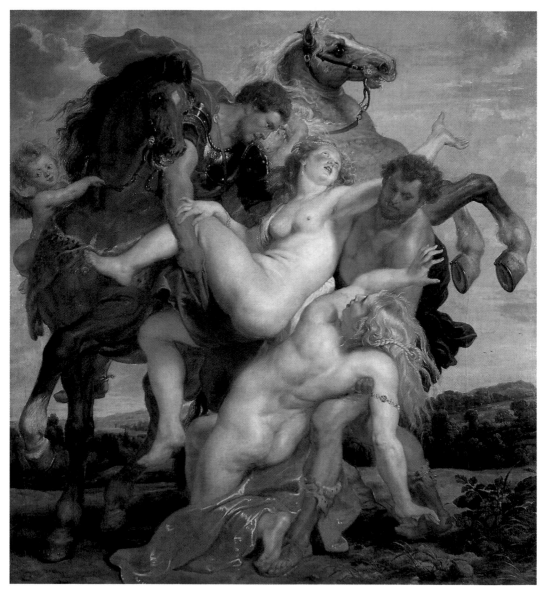

17 Peter Paul Rubens
The Rape of the daughters of Leucippus, 1618
Oil on canvas, 222 × 209 cm
Munich, Alte Pinakothek

This painting depicts the twins Castor and Pollux seizing Phoebe and Hilaria, daughters of the priest Leucippus. In spite of the artist's classical erudition, he chose to change the color of the twins' supposedly white horses, so as to accentuate the pallor of the women's ample flesh. Rape is made exciting, to the male protagonists, the male spectator, and even, Rubens implies, to the victims.

voyeurism into a brazen temptress whom the male viewer thereby feels entitled to enjoy. From there, one could argue, it is but a small step to the evident relish with which Rubens can depict a scene of violent sexual assault in the *Rape of the daughters of Leucippus* (**17**). Most commentaries on this painting describe it primarily in terms of its unabashed Baroque dynamism. That these writers can ignore the fact that it remains an image of violence done to women testifies to the dangerous ability of formal accomplishment to deflect attention from the implications of the subject matter. In marked contrast to both these paintings, Rembrandt's rendering of the Bathsheba story (**19**) shows a woman, no longer in the first flush of youth, sadly aware of the likely consequences of David's lust: a woman, in other words, richly—and all too rarely—endowed with an interior life, not merely a body, but a complete and individual human being.

Among all these images of naked women, Caravaggio's overtly homo-erotic images (**18**) strike a discordant—and refreshing—note. Once again, though, the contrast between the cheeky animal vitality of his male nudes and the passivity endemic to most depictions of the female nude is a striking one. As notorious for his violent and amoral lifestyle as for his art, Caravaggio produced his paintings of young boys for an explicitly homosexual clientèle. That this included at least one cardinal goes some way to explain the erotic charge of an ostensibly religious work such as *St. John the Baptist* (*c*1595, Musei Capitolini, Rome). The popularity of these works reveals the extent to which Caravaggio's paintings answered a real, and hitherto unrealized demand in the market.

Boucher's *Rest of Diana* (**20**) typifies the unashamedly titillating art of the Rococo era. Boucher, like most of his contemporaries, has robbed his classical source of all its darker

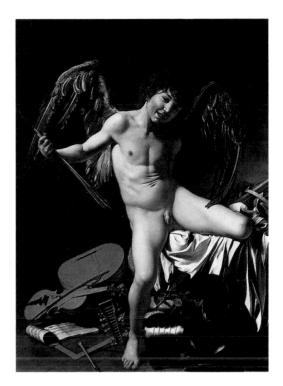

18 Michelangelo da Caravaggio
Love triumphant, *c*1600–03
Oil on canvas, 154 × 110 cm
Berlin-Dahlem, Staatliche Museu
The theme of *Love triumphant* is conventional enough: Cupid treading underfoot symbols of human achievement in war, music, and learning. Here Cupid is no pretty cherub (see 2 and 28), he is a cheeky and provocative Roman guttersnipe. Owned by the Marchese Vincenzo Giustiniano, the painting was kept discreetly hidden behind a curtain, and shown only to a select few, as the risqué climax to a tour of his art collection.

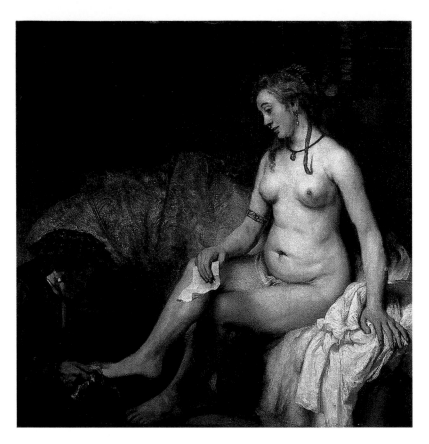

19 Rembrandt van Rijn
Bathsheba, 1654
Oil on canvas, 142 × 142 cm
Paris, Louvre

The Old Testament relates how King David saw Bathsheba, wife of one of his generals, bathing naked. Lusting after her, he exercised his seignorial prerogative, made her pregnant, and proceeded to ensure her husband's death in battle so as to be able to marry her. Unlike most renderings of the Bathsheba story, this image reveals a profound sympathy for the woman as helpless victim of her own physical attractions.

20 François Boucher
The Rest of Diana, 1742

Oil on canvas, 57 × 73 cm
Paris, Louvre

Actaeon, who in classical myth was torn to death by his own hounds for glimpsing Diana and her
nymphs bathing in the nude, has no place in this coyly precious world. Diana, the powerful and
vengeful virgin goddess of hunting and the moon, has been reduced to a decorative plaything.
The residual allusions to her divinity have far less significance than her artfully placed
necklace.

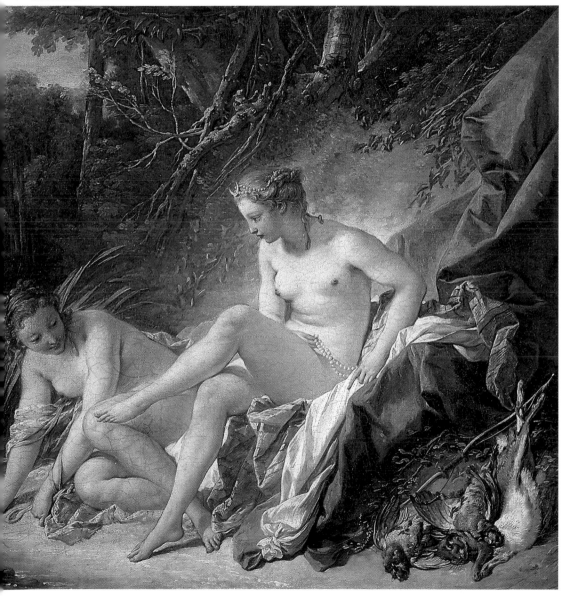

undertones and created instead a pretty and unthreatening image of narcissistic female flesh. This is an art often described, if not dismissed, as frivolously "feminine," and we know that women counted among the Rococo artist's most important patrons. Although it is tempting on this evidence to claim that this was the kind of art that women really wanted, it is far more likely that royal mistresses like Madame de Pompadour (for whom Boucher produced much of his work) endorsed such images in the knowledge, conscious or otherwise, that this was the image of woman their male protectors wanted, in art as in life. For better or for worse, this collusion in maintaining the status quo is an enduring product of a society based on inequality between the sexes.

Tradition and controversy

By the late eighteenth century, a reaction to all these "bosoms and bottoms" (the words are those of Diderot, the moralizing philosopher who was by no means immune to their charms) had set in, in the form of an apparently austere Neoclassicism that sought to reinstate the male nude as a symbol of more than merely physical beauty. This

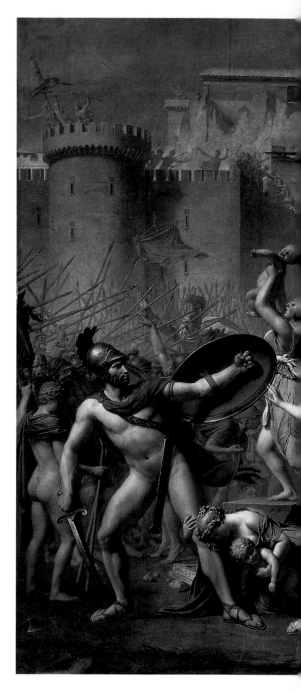

21 Jacques-Louis David
The Intervention of the Sabine women, 1797
Oil on canvas, 386 × 520 cm
Paris, Louvre
The Romans had abducted the Sabine women, and many years later, the Sabines attacked the Romans. The women, now mothers, interceded and persuaded the men to lay down their arms.

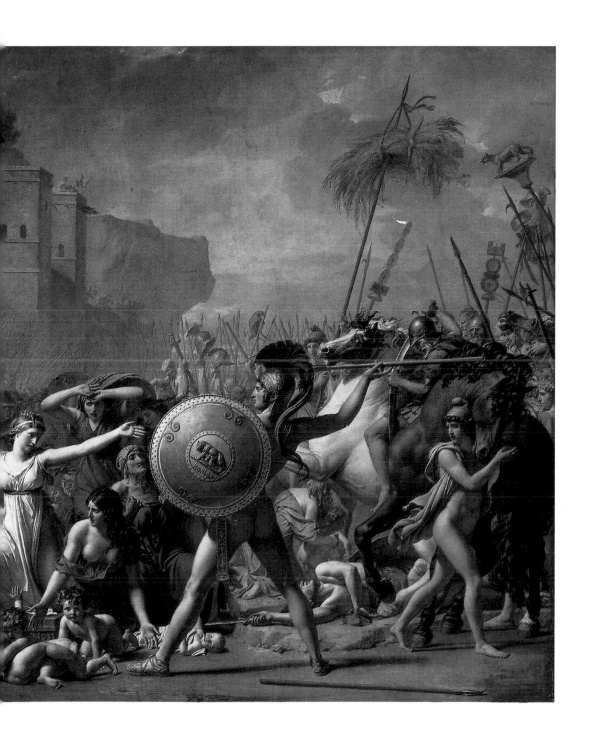

was easier said than done, however. Jacques-Louis David himself felt it necessary to publish a pamphlet to explain and defend the (distinctly self-conscious) nudity of the warriors in his *Intervention of the Sabine women* (**21**), and even so, was widely criticized for it. Stendhal, for instance, found it disgusting.

The day of the classically inspired, heroic male nude as the vehicle for complex meanings was clearly ending. (It is perhaps revealing that it only found collective expression once more in art favored by repressive political régimes—most notably, and disturbingly, in the art of the Third Reich and of Stalinist Russia.) Géricault's *Raft of the Medusa* of 1819 (**22**) represents a rare attempt to instill new life and meaning into the naked male body and, to some extent, succeeds. On a political level the painting was intended as an indictment of a corrupt government; on an artistic level, it pays homage not to the serene art of classical Greece but to the romantic turbulence of Michelangelo, as seen, for example, in his Sistine Chapel frescos. In spite of their attitudes of extreme suffering, these bodies retain a measure of nobility that few artists since Géricault have been able to find credible. To the modern sensibility Goya, in truly terrifying works such as *The Colossus* of *c*1815

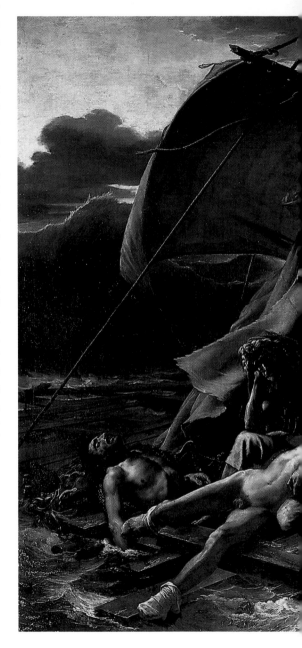

22 Théodore Géricault
The raft of the Medusa, 1819
Oil on canvas, 491 × 716 cm
Paris, Louvre

In 1816 the government frigate *Medusa* had sunk off the coast of Africa, due largely to the incompetence of the captain, a political appointee. One hundred and fifty passengers, deserted by the ship's officers, were set adrift on a small raft. Only a handful survived the ordeal. Although the artist researched his subject thoroughly, this overwhelmingly physical painting is ultimately a Romantic statement about the nobility of suffering in spite of all.

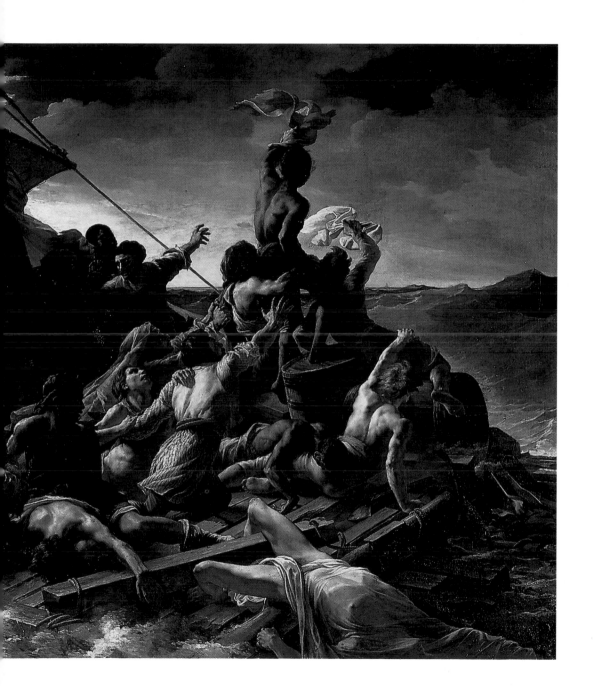

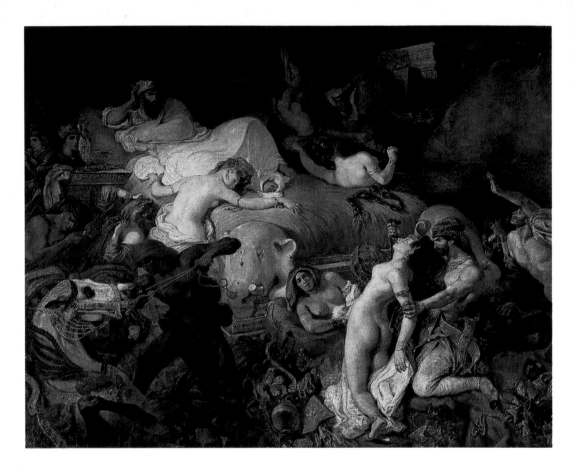

and *Saturn* of *c*1820 (both in the Prado), speaks far more convincingly of human suffering.

The passive female nude, however, continued to enjoy enormous popularity. Delecroix's *Death of Sardanapalus* (**23**) openly revives the Christian equation between female sexuality and death, made all the more shocking—and transparent—by the magnificently nonchalant pose of the Assyrian potentate whose suicide is the official subject of the picture. Although the painting met with considerable disapproval at the Paris Salon of 1827, this was mainly because its dynamic, melodramatic composition and its emphasis on color and texture rather than line— elements associated with Romanticism—

23 Eugène Delacroix
The Death of Sardanapalus, 1827
Oil on canvas, 395 × 495 cm
Paris, Louvre

Delacroix based his painting on Byron's play *Sardanapalus*, in which the vanquished, dissipated ruler throws himself on a funeral pyre. The violent putting to death of the concubines is the artist's own, gratuitous addition to the story. Théophile Gautier described these voluptuous figures as "flowers of the harem ... [who] surprised in the postures of death, which are precisely those of sensual delight, emit a violent odor of flesh."

Detail of 23

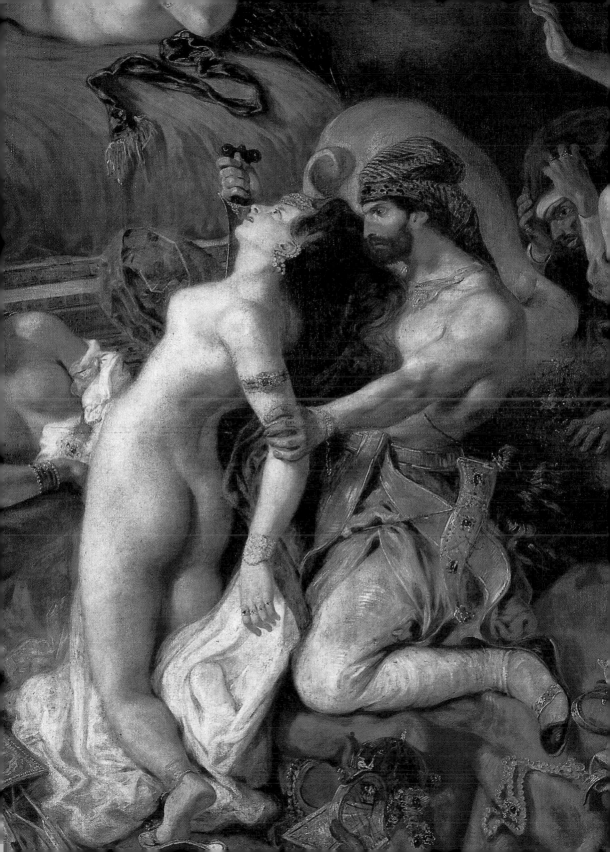

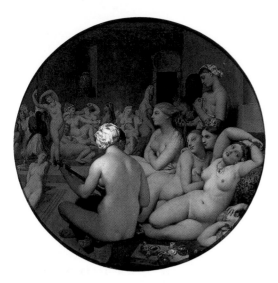

24 Jean-August-Dominique Ingres
The Turkish bath, 1862

Oil on canvas, 108 cm in diameter
Paris, Louvre

Ingres had noted a passage from a letter
written in 1717 by the wife of the English
ambassador to Constantinople, describing the
women's baths in that city (to which, of course,
men were denied access!), as early as 1819.
Forty years later he created this feverish vision
of female flesh, with its odd discrepancies of
scale and sense of pent-up sexuality, in which
he both quotes a number of his earlier
paintings and introduces new elements such as
the lesbian embrace in the foreground.

Detail of 24

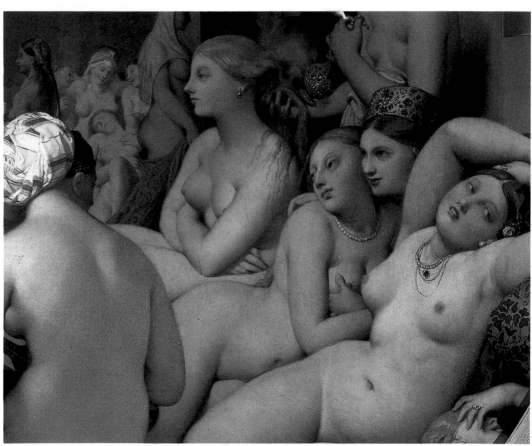

drew criticism from an already well entrenched classicist camp, of which Ingres was the undoubtedly the leader. In actuality, the work's evocation of oriental splendor and decadence, in which the harem fantasy plays a crucial part, has its counterpart, not only in many of Ingres's own paintings (his Odalisques, for example, and most notoriously *The Turkish bath* (**24**)), but in numerous academic paintings by other nineteenth-century artists. In these classicizing works, the tightly controlled, sculptural handling of the oil paint medium both masks and accentuates the paintings' strong erotic charge. In the medium of marble, much favored by sculptors of a Neoclassical persuasion, a similar tension is often at work (**25**). Denied this erotic charge, Neoclassical sculptures of the male nude, heroic and aggressive, tend to smack of hollow rhetoric.

Many of Ingres's paintings reveal the sexist assumptions which underlie both the works and the myths to which they refer, so blatantly as to be almost embarrassing. *Jupiter and Thetis* of 1811 (Musée Granet, Aix-en-Provence) shows an anatomically impossible Thetis extending an imploring and sexually suggestive body to a grotesquely monumentalized Jupiter. *Angelica saved by Ruggiero* of 1819 (Louvre, Paris, and National Gallery, London) embodies the pervasive myth of the damsel in distress being rescued by a knight in shining armor. (Its other manifestations include the story of Perseus and Andromeda, and St. George and the Dragon.) Here, as in the other renderings of the same myth, rescue looks suspiciously like a prelude if not actually to rape, at least to sexual intercourse. Yet again, the female victim, in an abandoned pose, hair loose to signify sexual readiness, is turned into a temptress inviting assault by the male.

Even rebellious Courbet, supposedly the

25 Antonio Canova
The Three Graces, 1815–17
Marble, 167 cm high
Duke of Bedford & Trustees of Bedford Settled Estate

The Three Graces are usually depicted with the two outer figures facing the spectator, the middle one facing away. Although Canova departs from convention in this respect, this smoothly anodyne sculpture confirms the way the three figures had lost any symbolic significance they may have once had, to become little more than an excuse to show youthful female flesh from different angles.

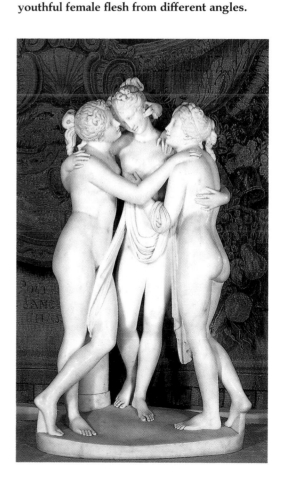

arch-realist of nineteenth-century French painting, seems to have found it impossible to escape convention when it came to painting the female nude. Most of his nudes fall well within conventional patterns of representation, whether of lesbian love (26), the reclining "Venus" (as in *Woman with a Parrot* of 1866, Metropolitan Museum of Art, New York) or the nymph in a woodland glade (as in *The Bathers* of 1853, Musée Fabre, Montpellier). The outraged response to this last painting (including the probably apocryphal story of how Napoleon III struck the backside of the corpulent bather with his riding crop) was almost certainly due to Courbet's unsettling juxtaposition of an unclassical, class-specific body (she was abused for being a fat *bourgeoise*!) and a supposedly classless, timeless classical setting.

It was left to Edouard Manet, who ironi-

26 Gustave Courbet
The sleepers, 1866
Oil on canvas, 135 × 200 cm
Paris, Musée du Petit Palais

This was commissioned by the former Turkish ambassador to St. Petersburg, Khalil Bey (who was also at this time the owner of Ingres's *Turkish bath* (see 24)). Courbet prefered the title *Laziness and sensuality*. Strictly for private consumption, this is one of the most explicit images of lesbian love ever painted. Painted by a man for another man, it says far more about male sexuality and preconceptions than it does about female desire.

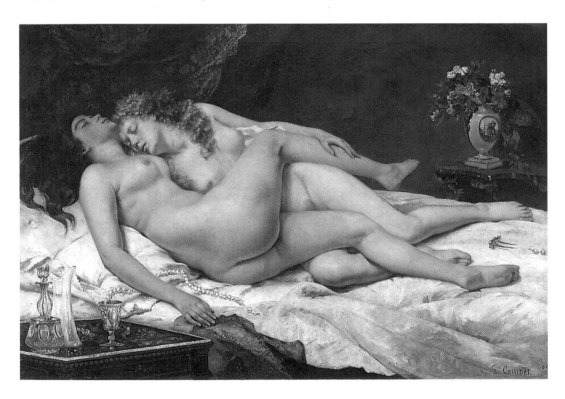

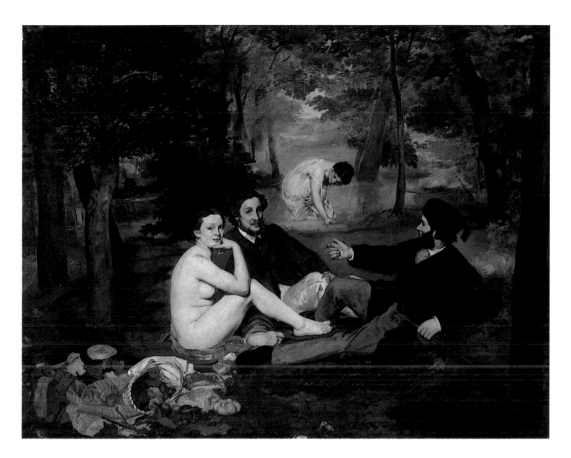

27 Edouard Manet
Le Déjeuner sur l'herbe, 1863
Oil on canvas, 208 × 264.5 cm
Paris, Musée d'Orsay

This painting seems to have been prompted by Manet's desire, after seeing some women bathing in the Seine, to produce a modern-day version of Titian's *Concert champêtre*. The models for the painting were the artist's brother, brother-in-law and Victorine Meurent, who later posed for *Olympia*. The apparent blasphemy of the compositional allusions to an engraving after Raphael's lost *Judgement of Paris* added fuel to the outrage caused by the contemporary nature of the "immoral" scene.

cally, unlike Courbet, never saw himself as an out and out rebel, to bring the complex issues surrounding the depiction of the female nude into the open. By juxtaposing clothed males with unclothed females, his *Déjeuner sur l'herbe* of 1863 (**27**) provoked an outcry, more for its embarrassing presentation of contemporary persons in contemporary dress than for any deeper reasons. In fact, by providing an insight into male perceptions of separateness (the men "civilized" in their clothes and conversation, woman set apart by her "natural" state of nakedness), it only makes explicit the assumptions underlying the painting from which it drew inspiration, Titian's *Concert champêtre* of *c*1510 (Louvre, Paris).

In Manet's *Olympia* (**29**), the unmasking of

conventions—witting or not—is more relentless still. Directly inspired by Titian's *Venus of Urbino* (**15**), but taking on board countless later images of the reclining female nude, the artist forces the spectator to consider the socio-sexual realities behind such images. Instead of showing the woman as passive and languorously abandoned, Olympia, unequivocally a modern courtesan, stares at us confrontationally, body tensed. The inclusion of the black servant (a ruse employed by many earlier painters) both emphasizes the whiteness of Olympia's skin and hints at the assumption of racial inequality underlying such a juxtaposition. That Manet succeeded in outraging an art public inured to the "soft porn" of artists such as Cabanel (**28**) or Ingres, whose *Turkish bath* (**24**) was painted only three years earlier, is testimony to the artist's integrity and that public's hypocrisy.

A major reason for August Renoir's abiding popularity is undoubtedly his hedonistic celebration of the female body. His vision is

28 Alexandre Cabanel
The birth of Venus, 1863
Oil on canvas, 130 × 225 cm
Paris, Musée d'Orsay
This is a typical example of the kind of feminine image that was staple fare at the Paris Salon, although its use of a classical subject to mask its true intent was a ruse established many centuries earlier. This passive, provocative and (to the male imagination) sexually available woman is only a more blatant and vulgar cousin of Titian's *Venus of Urbino* (15). (Botticelli's *Birth of Venus* (8), in comparison, seems positively chaste.)

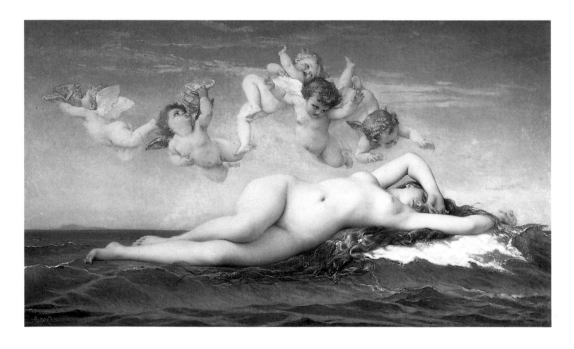

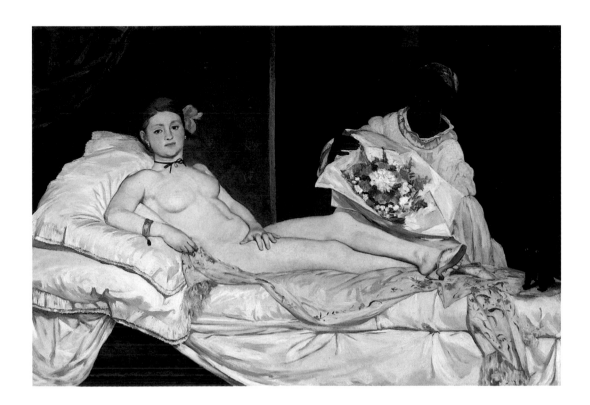

29 Edouard Manet
Olympia, 1865
Oil on canvas, 130.5 × 190 cm
Paris, Musée d'Orsay

The public at the 1865 Paris Salon were so incensed by this painting that it had to be hung beyond the reach of physical attack. Critics and cartoonists had a field day. One writer described the nude woman as "a female gorilla made of india rubber, outlined in black;" others focused on the way her hand was "obscenely" clenched over her genitals. The painting's obvious allusions to a hallowed tradition of reclining Venuses clearly added fuel to the fire.

indeed a seductive one: a world of beautiful young female flesh, narcissistically self-absorbed and closely allied to the benign forces of nature (**30**). As with the Venetians and the eighteenth-century Rococo painters whom Renoir considered his mentors, a sensuous painterly technique is essential to the appeal of his work. On closer inspection, however, his view of women is rather more suspect. Only, as the artist himself once confessed, when women were "winsome and pleasing to men"—in other words, when they conformed to his, and many other men's ideal of femininity—were they of interest to him.

Compared with Renoir's nudes, those by Degas (also painted mainly later in the artist's life) have an awkward, "lived" quality to them that can only be refreshing. His pastel images of women bathing (**31**) are certainly unclassical, both in their abrupt compositional elements (inspired by photographs and Japanese prints) and their treatment of everyday life-situations in which women do indeed remove their clothes. It is indicative of Degas's integrity that he himself worried lest he had reduced his women to the level of animals seen, voyeuristically, through a keyhole.

A great deal of late nineteenth-century art and literature testifies to a virulent resurgence of misogyny, in the guise of an obsession with the threatening, man-eating *femme fatale*, be she Salome, Judith, Delilah, Circe, Medea, Medusa, or the Sphinx. This may well have been due not merely to a profound and widespread *fin-de-siècle* malaise, in which male fears and anxieties found a focus in the figure of the emasculating woman, but more specifically with the beginnings of a concerted fight for women's rights (and, above all, the vote). In Moreau's painting (**32**), Salome is both sexually alluring and deadly—a compelling combination of qualities common to most

30 **Auguste Renoir**
The torso of a young girl in sunlight, 1870
Oil on canvas, 81 × 64 cm
Paris, Musée d'Orsay
When this painting was exhibited at the second Impressionist exhibition of 1876, one critic, used to the smooth, unbroken surfaces of academic art (cf. **28**), wrote: "Try to explain to M. Renoir that the torso of a woman is not a mass of decomposing flesh, with green and purple patches like a corpse in a state of utter putrefaction." In retrospect, however, it is clear that for all its technical radicalism, this painting perpetuates a well entrenched stereotype of mindless female beauty.

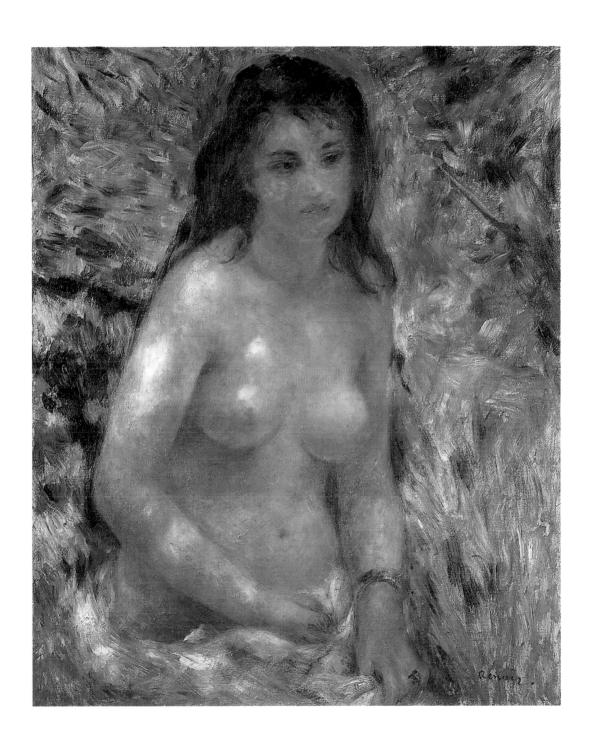

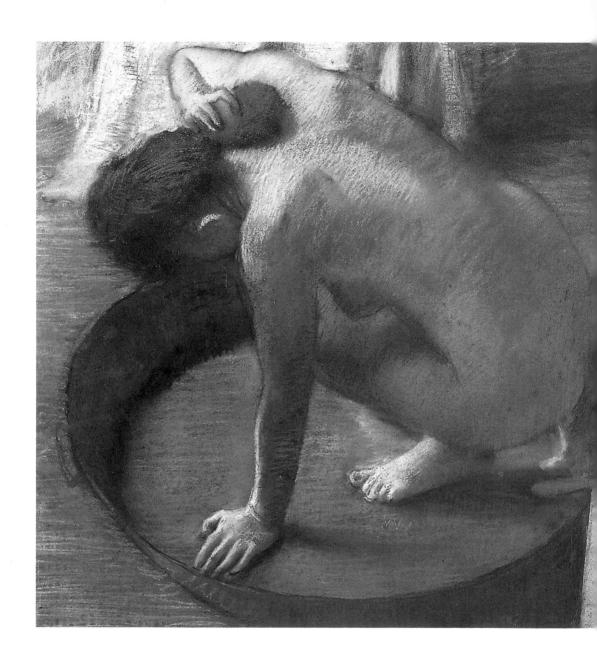

Symbolist images of (usually naked) woman, using her sexuality to get her own evil and destructive way.

An even deeper, because more directly personal, fear of female sexuality pervades the work of Edvard Munch, whose *Madonna*, a color lithograph of 1895–97, goes so far as to turn the Christian mother of God into a seductive vamp. Her power over the male, and even over life and death, is forcefully symbolized by the sperm-like forms in the margins of the image. In *Puberty* of 1894–95 (**33**), a pubescent female figure tensed with fear at the onset of sexual maturity becomes the oblique embodiment of Munch's neuroses.

After a century or more of bland academicism in sculpture, Auguste Rodin was able to breathe new symbolic life into both the male and female nude, in a way that can also—paradoxically—be seen as marking the end of an era of naturalism. His most truly original works are probably those which fall outside obvious conventions: his *Iris* of 1890–91, for example, *The crouching woman* of 1882 (both Musée Rodin, Paris) or *She who was once the helmetmaker's beautiful wife* of 1888 (**1**). Even the last of these, however, relies on the implicit recognition of a norm—namely, youthful female beauty—for its impact: its pathos depends on an awareness of a youthful female beauty that is no more.

31 Edgar Degas
The tub, 1886
Pastel on paper, 60 × 83 cm
Paris, Musée D'Orsay
For all its apparent naturalness, the scene has been carefully staged by the artist in the studio, and the unorthodox composition in fact accentuates the artificiality of the situation. As with countless earlier images of the female nude, the spectator is forced into the position of voyeur.

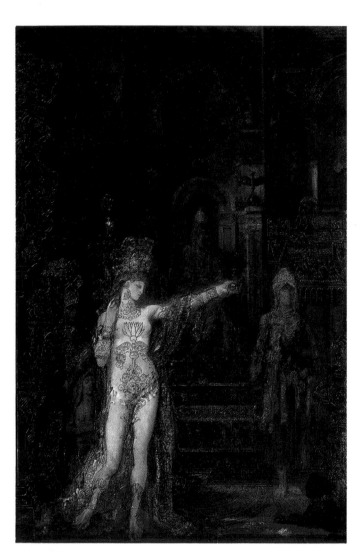

32 Gustave Moreau
Salome dancing, 1874–76
Oil on canvas, 92 × 60 cm
Paris, Musée Gustave Moreau

Salome, whose seductive dancing persuades her stepfather, Herod, to deliver to her the head of St. John the Baptist, became the very epitome of the *femme fatale*. Moreau painted several versions of the subject, all redolent of a decadent exoticism. One of them, exhibited at the 1876 Salon, inspired a lengthy description in J. K. Huysmans's *A Rebours* (Against Nature). To the novel's hero, Salome is "the symbolic deity of indestructible lust ... the monstrous Beast."

33 Edvard Munch
Puberty, 1894–95
Oil on canvas, 150 × 111 cm
Oslo, National Gallery

Munch's attitude to women was clearly one of fear mingled inextricably with fascination. (Significantly perhaps, his mother had died when he was five, his sister when he was thirteen.) Here, an accident of light as he drew from the model is put to brilliant use as the dark, anthropomorphized shadow (perhaps a hint of the soul leaving the body) that threatens the tensed figure of the pubescent girl.

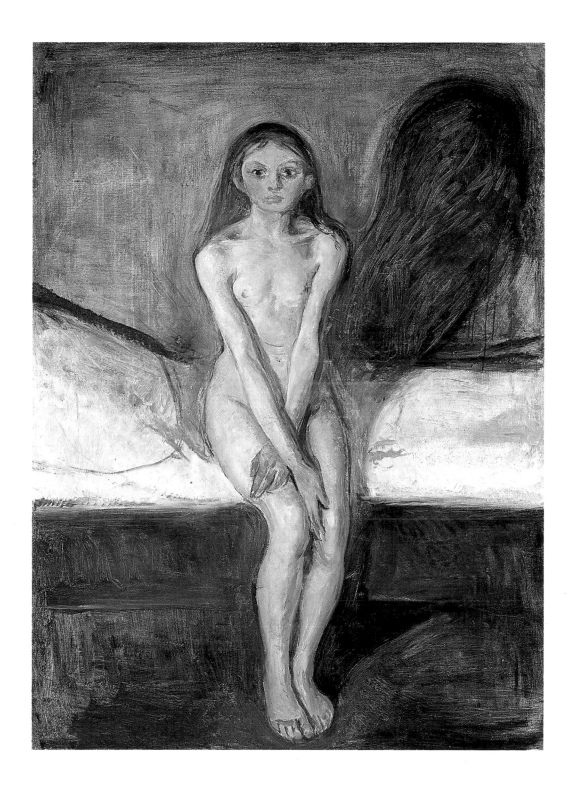

The Nude in the twentieth century

To a large extent, the old sexual conventions have provided a basis even for the most stylistically radical of twentieth-century images of the nude. Indeed, much of the shock value of such images resides precisely in their defiance of expectations in a conventional context. A radical style, however, can easily deflect attention from what is often a misogynistic impulse on the part of the male artist to do violence to the female form. Picasso's famous *Demoiselles d'Avignon* (**34**), for example, undoubtedly constitutes a stylistic landmark in the history of modern art. Its emphatic rejection of traditional Western representations of the nude does not, however, prevent it from being an expression of violent hostility against the female of the species. Indeed, one could argue that this constitutes an important part of its power.

Neither Henry Moore nor Picasso, in his more benign and classicizing works, can be accused of misogyny in the usual sense. Nevertheless, for all the formal inventiveness of Moore's work (**35**), his persistent concern with the notion of woman as landscape, as part of a primeval order, is essentially traditional. Similarly, Jean Dubuffet (**36**) declared his defiance of conventional standards of beauty and ugliness by paying homage to the great fertility icons of prehistory (**3**), but in so doing he perpetuates the age-old, and ultimately restricting, stereotype of woman as part of the natural world.

Grotesque females, most of them prostitutes, feature prominently in Otto Dix's work of the 1920s, as they do in the work of fellow *Neue Sachlichkeit* artist George Grosz. Both painters depict the women's deformed bodies with a potent mix of relish and disgust, evidently viewing them both as victims and as symbols of the corruption of Weimar Germany. The grotesque rears its head again in Magritte's *Rape* (Menil Foundation, Houston). This image is meant to shock, but also, presumably, to prompt speculation as to the nature of the relationship between sex and power, the implicit and explicit. Although the painting smacks uncomfortably of a crude schoolboy humor, it continues to exercise a disturbing fascination. When fellow Surrealist Max Ernst depicts the female nude in his paintings of the 1930s (such as *The robing of the bride* of 1939 (**37**)), his distortion of the female body immediately recalls his northern European heritage, while the way he allies the female form with fantastic and threatening creatures of his imagination evokes the cautionary images of Jerome Bosch. The Belgian Surrealist Paul Delvaux, for all the deliberate bizarreness of his images, is obsessed with the death-and-the-maiden theme, the age-old conjunction of female beauty and mortality.

That entrenched attitudes die hard is perhaps most obvious in those works of modern art which, unlike the ones discussed above, seem to offer a positive, hedonistic view of woman. For all their seductiveness, visually appealing works by artists such as Henri Matisse or Raoul Dufy do much to perpetuate the stereotype of the virile, active (male) artist and passive, sexually available (female) nude model. The female nudes of Pop artists such as Tom Wesselman (**38**) or Allen Jones belong to a similar category, but additionally refer to a mass-media culture in which the stereotype of the woman existing solely for the sexual gratification of the man finds so pervasive a place.

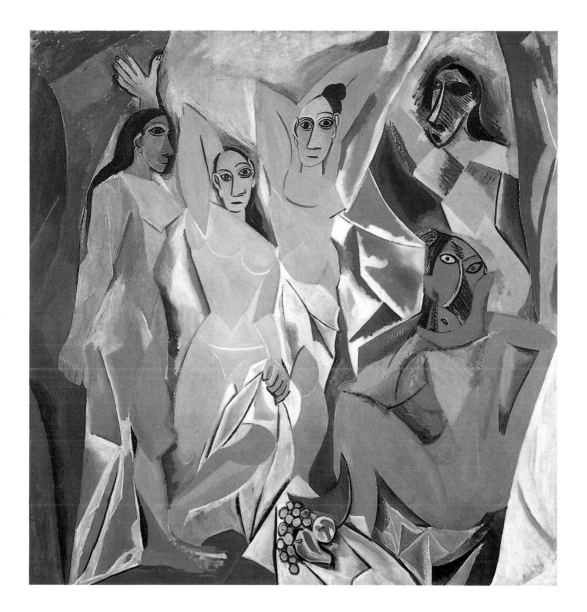

34 Pablo Picasso
Les Demoiselles d'Avignon, 1907
Oil on canvas, 244 × 234 cm
New York, Museum of Modern Art

We know that these female figures were originally intended to be read as prostitutes (the title refers to the Calle d'Avignon, a street in Barcelona's red-light district). Early studies for the painting, moreover, reveal that Picasso once meant to include a man holding a skull. The "primitive" references are not merely a formal device, but reveal a deep fear of female sexuality in its familiar alliance with warnings of mortality.

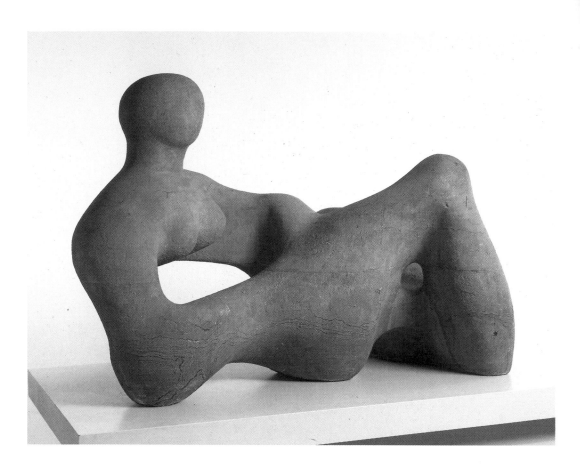

35 Henry Moore
Recumbent figure, 1938
Green Hornton stone, 88.9 × 132.7 × 73.7 cm
London, Tate Gallery

For all its abstraction and ambiguity of form, and the radical way in which forms (particularly the breasts) are defined as much by the surrounding space as by solid mass, this sculpture clearly alludes to the convention of the reclining Venus. More obviously, by evoking a sense, however dignified, of primeval natural forms eroded by the elements, it reiterates the age-old tendency to see a woman's body as analogous to landscape.

36 Jean Dubuffet
Le Métafysix, 1950
Oil on canvas, 116 × as89.5 cm
Paris, Musée Nationale d'Art Moderne

In images and words alike, Dubuffet fought for a recognition of standards of beauty far removed from the still dominant classical one. Drawing on sources as diverse as prehistoric fertility figures (see 3) and crude urban graffiti, he has created an image of woman that is both repellent and curiously impressive, but whose identity is still defined entirely by her sex.

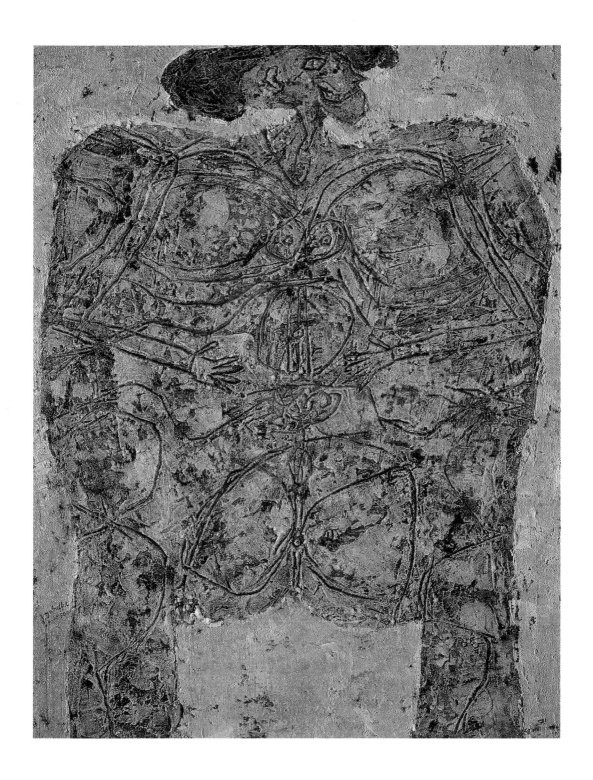

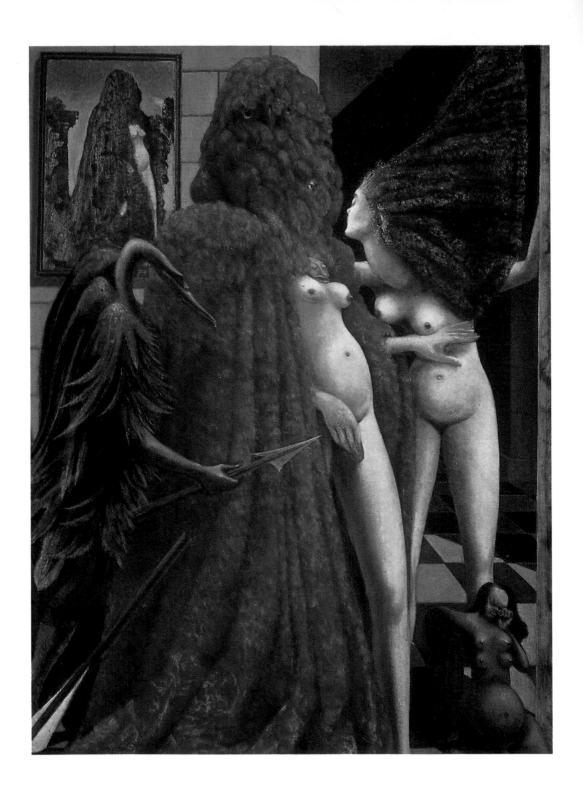

37 Max Ernst
The robing of the bride, 1939
Oil on canvas, 130 × 96 cm
Venice, Peggy Guggenheim Collection

Although (as Ernst no doubt intended) the precise meaning of this mysterious and disturbing painting remains elusive, there is little doubt that woman is portrayed here as both desirable and alien, threatening and vulnerable. The female nudes' elongated proportions and their alliance with a grotesque world of hybrid monsters recall the imagery of Northern medieval art.

38 Tom Wesselman
Great American Nude, No.57, 1964
Oil on canvas, 130 × 165 cm
New York, Whitney Museum of American Art

Suggestively parted mouth, erect nipples, even the bikini suntan marks declare this woman's kinship with the female pin-up of photographic pornography. Her pose, and the setting in which she is depicted, however, reveal her art-historical ancestry (see 15). Stylistically, this image pays homage both to the art of Matisse and to the brash world of advertising. Any irony intended by the title is belied by the blatant eroticism of the image itself.

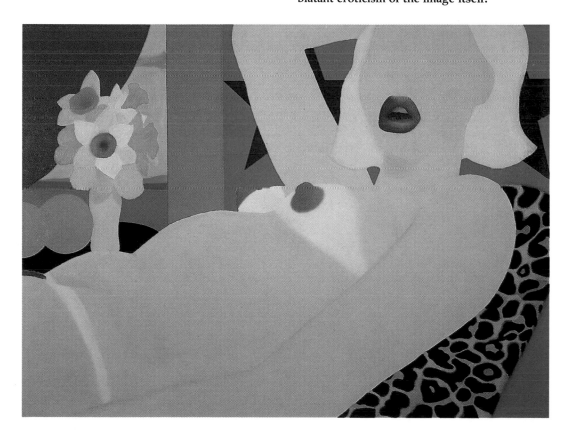

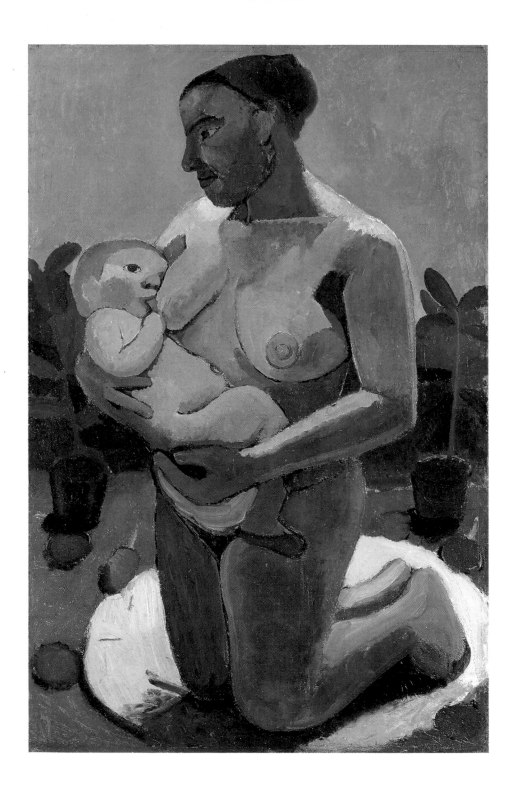

New attitudes

In the history of Western culture, the making of art has been construed as an essentially masculine activity, while women have consistently been relegated to the domain of childbearing and domesticity. Culture, in other words, has been seen as the preserve of the male, nature that of the female. If woman enters the cultural milieu, she has done so most often as model, muse, or mistress (or a combination of the three).

Since, moreover, a tacit convention has long prevailed that male artists address themselves primarily to a male viewer (and never more so than when they depict the female nude), the position of the female artist and the female viewer is likely to be ambiguous and problematic. Until the late nineteenth century, ostensibly for reasons of morality, women were denied access to drawing from the nude – the discipline that for so many centuries lay at the very heart of artistic competence. That they were allowed to tackle the nude only at a time when the centrality and relevance of life drawing were increasingly under challenge by the avant-garde is probably no coincidence.

Nevertheless, many women were to find the naked body central to their concerns as artists. Paula Modersohn-Becker (**39**) shows an aspect of femaleness rarely treated by male artists: namely, the intensely physical and intimate sensuality of the relationship between mother and child, as conveyed largely by their emphatic nakedness. In so doing, she paved the way for later women artists to explore hitherto taboo areas of female bodily experience, notably childbirth and menstruation, in which pain is a central ingredient. Gwen Hardie's *Venus with Spikes* (**40**), for example, acts as a healthy and sobering antidote to the plethora of Venuses

39 Paula Modersohn-Becker
Mother kneeling with a child, 1907
Oil on canvas, 113 × 74 cm
Berlin, Staatliche Museum

Although the emphatic physicality of this image sets it apart from most images of motherhood painted by men, its frame of reference remains that of woman as earth mother. Modersohn-Becker's early death, soon after giving birth to her only child, stands as an ironic and tragic commentary on the discrepancy between this idealized image and the hazards of actual childbirth.

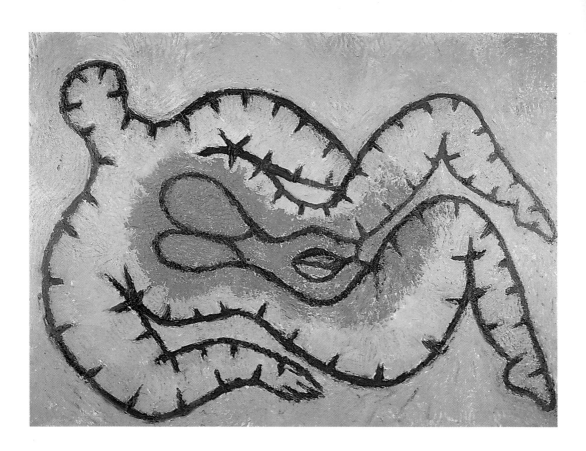

40 Gwen Hardie
Venus with spikes, 1986
Oil on canvas, 150 × 200 cm
Lisbon, Gulbenkian Foundation

Young Scottish artist Gwen Hardie effectively counters the conventional image of the reclining goddess of love by providing an uncompromising and graphic image of woman as victim of her own anatomy. Significantly, it is the reproductive organs that are given greatest prominence. Its large size and close-up, diagrammatic quality endow the image with a primitive monumentality.

as perceived by men.

However, the fact remains that an emphasis on these aspects of womanhood may well reinforce the traditional association of woman with the natural order of things, the notion of woman as, above all, a body. Few women would deny the importance of biology in the formation of their identities; but most today would argue that biology is all too often confused with social conditioning to ensure that women know their proper place. Yet it is far easier to recognize that cultural stereotypes work to prevent women from being perceived as fully rounded human beings than to escape those stereotypes completely.

Another, related problem facing modern women artists is their wish to express their own sexuality by exploring an eroticism that is not insulting or degrading to women. On one level Sylvia Sleigh's deliberate inversions of the male artist/female model relationship (**41**) are a means of exposing the power of

41 Sylvia Sleigh
Imperial nude: Paul Rosano, **1975**
Oil on canvas, 105.6 × 152 cm
Collection of the Artist

Like much of Sleigh's work of the 1970s, this is a witty and embarrassing exposé of social and sexual conventions. Most importantly, perhaps, it reveals how utterly unused we are to seeing men in the passive, decorative roles we take almost for granted when the model is female. In contrast to many images of the female nude painted by men, moreover, the artist is obviously concerned to convey the model's individuality.

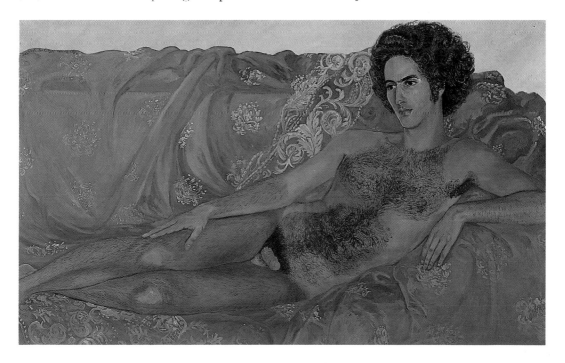

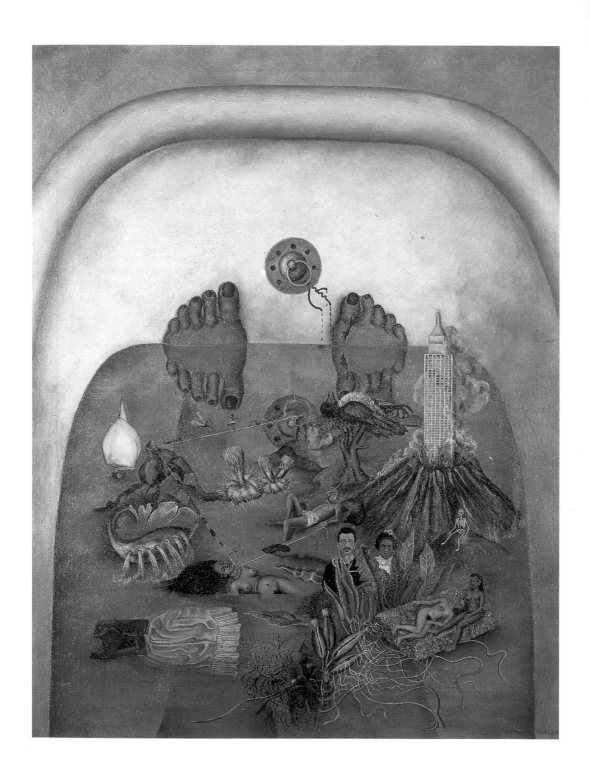

43 Ana Maria Pacheco
The Three Graces
(detail), 1983
Polychromed wood,
Wolverhampton, Art Gallery

Pacheco's renderings of the naked female body are both comic and profoundly unsettling. In marked and ironic contrast to a work such as Canova's *Three Graces* (25), woman here is a force to be reckoned with—fearful of the vulnerability consequent upon her nakedness, perhaps, but full of a knowing, potentially threatening energy.

42 Frida Kahlo
What the water gave me, 1938
Oil on canvas, 97 × 76 cm
Collection Tomás Fernández Márquez

Hailed by the Surrealists as a "natural", Kahlo's paintings were her means of coming to terms with a life filled with great physical pain. Here, her naked feet in the bathtub become grotesque crab-like forms, nail polish allied to blood. In the centre of the composition, a rope lassos the naked body of a drowned self-image, menaced by insects.

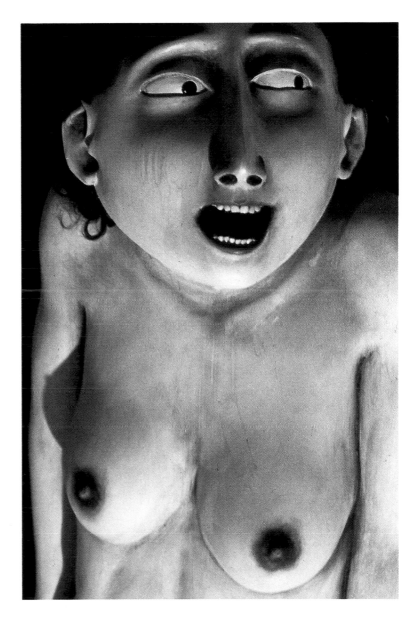

44 Egon Schiele
Standing male nude (Self-portrait), 1910
Pencil and tempera on paper, 55.8 × 36.9 cm
Vienna, Albertina

All Schiele's nudes, whether self-portraits, images of women, or copulating couples, are disconcertingly explicit, conveyed with a tension and raw urgency that still have the power to shock. Although he was once imprisoned for the alleged obscenity of his images, the generalized sense of despair they express is worlds apart from the short-term, localized, and exploitative titillation of most pornographic images.

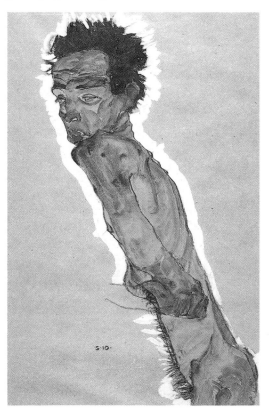

cultural conditioning; on an equally important level they are a sincere attempt to produce tender and sensuous images of naked male beauty. Numerous other female artists have addressed themselves to the relationship between sex and power. Brazilian-born, British-based artist Ana Maria Pacheco is probably best-known for her powerful, ambiguous and deliberately disturbing sculptures of male power-games, in which naked men are often depicted as menaced by clothed aggressors. Nakedness in this context clearly signifies vulnerability. When she depicts naked women (**43**), Pacheco tends to offer a mocking and subversive parody of the stereotype of the passive female.

Many woman artists have tried, consciously or not, to circumvent the risk of exploitation inherent in the traditional artist/model relationship by turning to the genre of the self-portrait. That many of these self-portrait images show the artist unclothed probably reflects a widespread feeling that nakedness in this context signifies not sexual availability but a rigorous self-scrutiny. The nude self-portraits of Modersohn-Becker and the intensely felt autobiographical paintings of Frida Kahlo (**42**) are very much a case in point.

In the case of the not-quite-extinct male nude as depicted by male artists, the most memorable modern images are probably those produced out of a sense of profound unease (of which Dürer's *Naked self-portrait* (**12**) was an isolated early example). Egon Schiele's naked self-portraits (**44**), angst-ridden and theatrical, in which sexual self-scrutiny is clearly an experience both pleasurable and agonizing, come immediately to mind. Stanley Spencer (**45**), for all his avowed belief in the sanctity of sex, produced some of the most powerful and intimate images of physical alienation ever painted. Contem-

45 Stanley Spencer
Double nude portrait: The artist and his second wife, 1936
Oil on canvas, 91.5 × 93.5 cm
London, Tate Gallery

Although Spencer made much of his defiance of bourgeois sexual morality, his own sex life was
something of a disaster. Although both bodies are rendered with an honest, minute, and
embarrassing attention to detail, Spencer seems to envy his wife's air of being at home in her
body; his expression is a complex one that may also include hostility and hunger. If only, he
seems to be saying, we could indeed be like the leg of mutton, unburdened by a mind and
feelings. . . .

46 Mario Dubsky
Pan by moonlight, 1983
Charcoal on paper, 60 × 40 cm
London, Boundary Gallery

**Significantly, Dubsky chose the more
private—if no less powerful—medium of
drawing for his most intimate and explicit
homo-erotic statements. For all its defiant
paganism, his vision of the classical past is
ambiguous and complex. The two figures in
this image are locked together in a relationship
that is passionate but not entirely pleasurable.
Pan remains fiercely inscrutable, the young
man almost pleading.**

porary British artist Lucian Freud paints nudes, both male and female, in a similar, profoundly disquieting vein. Flesh may not be beautiful, but our bodies are all we have.

Finally, a small but growing number of male artists—among them David Hockney, Patrick Proctor, and Mario Dubsky (**46**)—have openly declared their homosexuality, and sought to produce images of the male nude that express their belief in the validity of a sexual bond between men. Although this belief takes many forms, a number of these images are informed by an ambivalent homage to the culture of classical Athens, in which homosexuality was deemed the fullest and most ennobling of human relationships.

It should be clear that images of the naked human body are far more than pretty (or occasionally ugly) pictures. Not only do they reflect attitudes about the body and the role of the sexes in the real world, but they serve to reinforce and perpetuate those attitudes in ways that are not always immediately obvious. Art, in other words, is disconcertingly powerful, and inescapably linked with real-life sexual politics. While an awareness of these complex issues need not prevent us from enjoying art as art, it should teach us that the aesthetic experience is both less "pure" and more interesting than we may have believed.